MW00769426

KAWAII
DOGGIES

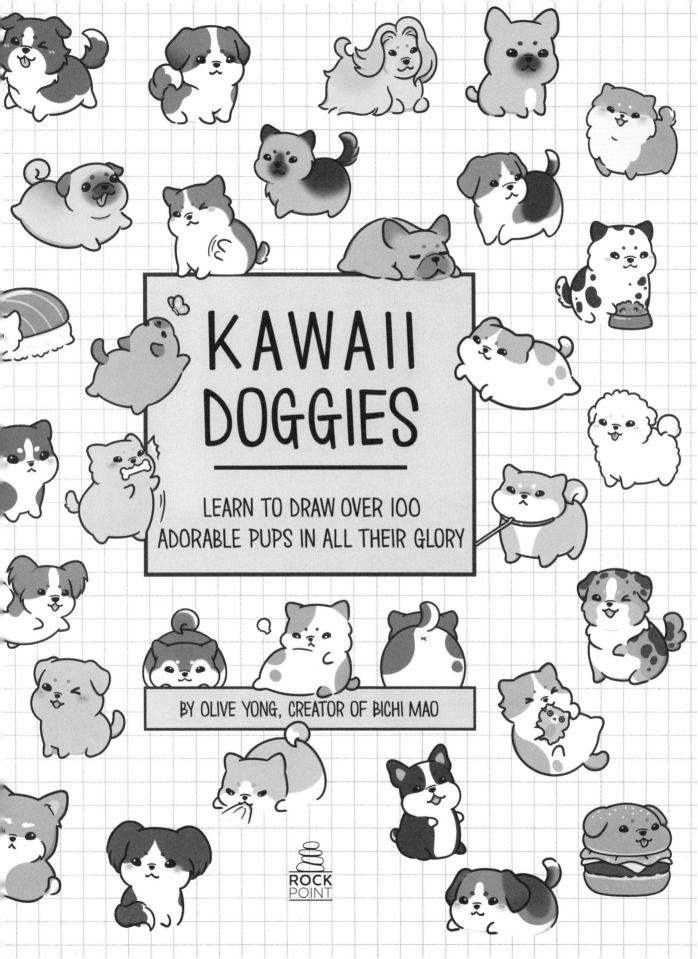

KAWAII DOGGIES

LEARN TO DRAW OVER 100 ADORABLE PUPS IN ALL THEIR GLORY

BY OLIVE YONG, CREATOR OF BICHI MAO

ROCK POINT

Inspiring | Educating | Creating | Entertaining

Brimming with creative inspiration, how-to projects, and useful information to enrich your everyday life, quarto.com is a favorite destination for those pursuing their interests and passions.

First published in 2023 by Rock Point, an imprint of The Quarto Group,
142 West 36th Street, 4th Floor, New York, NY 10018, USA
T (212) 779-4972 F (212) 779-6058 www.Quarto.com

Rock Point titles are also available at discount for retail, wholesale, promotional and bulk purchase. For details, contact the Special Sales Manager by email at specialsales@quarto.com or by mail at The Quarto Group, Attn: Special Sales Manager, 100 Cummings Center Suite, 265D, Beverly, MA 01915, USA.

10 9 8 7 6 5 4 3 2 1

ISBN: 978-0-7603-7985-1

Library of Congress Control Number: 2022944440

Publisher: Rage Kindelsperger
Creative Director: Laura Drew
Editorial Director: Erin Canning
Managing Editor: Cara Donaldson
Editorial Assistant: Katelynn Abraham
Cover and Interior Design: Kim Winscher

Printed in China

This book is dedicated to my family, who always supported my
passion for creating art and believing in me.

To my partner, who not only inspired me but who has also been
patient and encouraging throughout my journey.

To all my Bichi Mao comic readers, who enjoy my
work and share it with the world.

To my editor, Erin, and the team at The Quarto Group, who gave
me this great opportunity and showed me the ropes through
publishing my third book—without their guidance and efforts, this
book would have never come to fruition.

Lastly, I'm grateful that I did not give up and persevered until
today. W. Clement Stone once said, "Aim for the moon.
If you miss, you may hit a star."

CONTENTS

HI!

My name is Olive Yong, and I'm a self-taught artist from Malaysia. Drawing has always been a passion of mine, and I mostly work with pencil and paper. In June 2019, I was introduced to digital drawing and started working with the Procreate program on the iPad. From there, I began to post my art across social media platforms under the name Bichi Mao. Within a year, Bichi Mao had amassed a strong online following that continues to grow. I'm really surprised that people enjoy and love what I'm doing, and their support gives me strength to continue creating.

Bichi Mao is a cute and relatable webcomic series revolving around cat characters presented in an adorable and simplistic art style that I show you how to draw in my first book, *Kawaii Kitties*! I also have a second webcomic series called Pip and Bun about a cute dog and bunny couple. Through my comics, I try to portray everyday ups and downs. What motivates me to keep drawing and sharing my art is that I want to continue spreading positivity and make people smile. I also enjoy sharing my views on certain topics to bring awareness to the public in hopes of helping to make the world a little kinder.

I hope that this book inspires you to not only learn how to draw these adorable doggies, but also to create your own characters, whether they are dogs or something entirely different.

What Is Kawaii?

You might have heard the word. You have probably seen the hashtag. You definitely know the style. But what, exactly, does kawaii mean?

Kawaii is a Japanese concept or idea, dating back to the 1970s, that translates closely to "cuteness" in English. In Japan, the usage of the word is quite broad and can be used to describe anything cute, from clothing and accessories to handwriting and art. So, if you are a fan of emoji art or the style of beloved characters like Hello Kitty, Pokémon, or Pusheen the Cat, then you already know and love the kawaii style of art!

While there are many interpretations as to what constitutes the "kawaii" art aesthetic, most people can agree that kawaii art is usually composed of very simple black outlines, pastel colors, and characters or objects with a rounded, youthful appearance. Facial expressions in kawaii art are minimal and characters are frequently drawn with oversized heads and smaller bodies.

How to Use This Book

After some helpful information here in the beginning of the book about tools and drawing techniques, there are over one hundred step-by-step tutorials divided into seven sections: Favorite Breeds, Puppies, Poses & Moods, Daily Activities, Dress-Up, Bon(e) Appétit, and Portraits. At the end of the book are Doggy Coloring Pages with lots of kawaii doggies for you to color and decorate.

• •

Tools

Feel free to draw your kawaii doggies with whatever you have available to you, but here are some suggestions.

TRADITIONAL TOOLS
If you're drawing your dogs with traditional tools, use a pencil, such as a 2B/HB (aka a #2 pencil) for the initial sketch, and then use a black ink pen to finish your drawing—once your sketch is final. You may want to invest in a high-quality eraser to easily get rid of any unwanted lines and marks. A ruler may also be helpful for when you're working with straight lines.

For coloring your doggies, I recommend using color pencils, crayons, or watercolors. Have fun experimenting with what works best for you. The coloring pages on page 140 are a great place to practice!

DIGITAL TOOLS
There are a number of software programs and apps for drawing digitally, whether you prefer drawing on a desktop, laptop, or iPad. Like I mentioned earlier, I prefer using Procreate on an iPad, but see what works best for your artwork, equipment, and budget.

Regarding the brushes included with these programs, I like the Monoline brush in Procreate, but again, have fun experimenting.

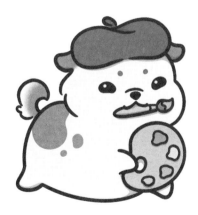

DRAWING YOUR DOGGIES

I like to use a lot of curved lines in my drawings, which help contribute to that Kawaii, or cuteness, factor. Here are some of the basic shapes you will see throughout the tutorials in this book.

Body Shapes

Try it out!

Try it out!

Try it out!

Ear Shapes

Leg Shapes

Try it out!

Try it out!

Try it out!

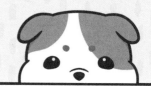

Tail Shapes

Try it out!

Try it out!

Try it out!

Try it out!

Try it out!

Try it out!

FACIAL EXPRESSION DIRECTORY

Facial expressions are what give these doggies their Kawaii factor. Here, I show you some of my favorite facial expressions.

Content

Happy

Playful

Angry

Zonked Out

Sleepy

Concerned

Silly

Dizzy

Surprised

Sad

In Love

COLORING YOUR DOGGIES

These are the colors I prefer to use on my doggies, but you can make your doggies any color, even beyond what is realistic. Regarding patterns, every doggy is unique, so here, I share some examples for inspiration. Don't forget to practice using the coloring pages on page 140!

Color Palette

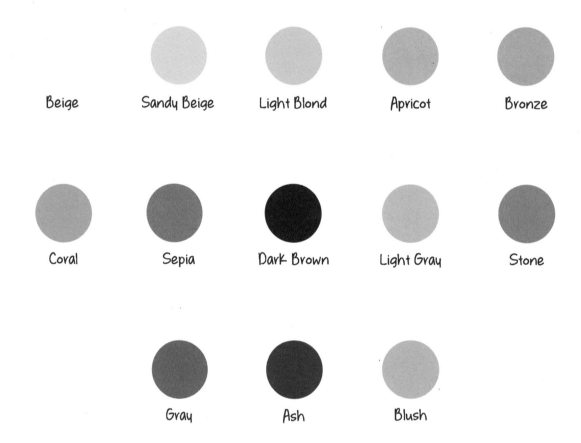

Beige Sandy Beige Light Blond Apricot Bronze

Coral Sepia Dark Brown Light Gray Stone

Gray Ash Blush

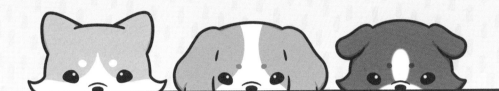

Examples of Markings

FAVORITE BREEDS

Beauty comes in all shapes and sizes.

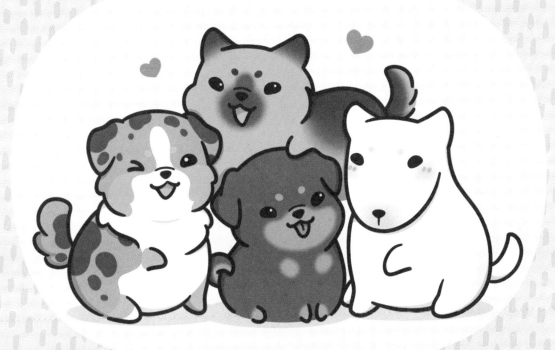

GOLDEN RETRIEVER

1. Draw the top of the head, the floppy right ear, and the top of the left ear.

2. Complete the ears with a little fur detail.

3. Draw both sides of the head with a curved left cheek.

4. Add some fur detail to the neck.

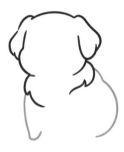

5. Draw the front and back of the body and the inner-front leg.

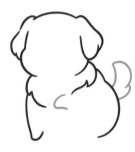

6. Add the outer-front leg so that it is raised and pointed in. Draw the fluffy tail.

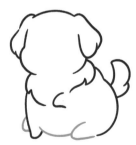

7. Complete the body by drawing the underside. Add the back legs.

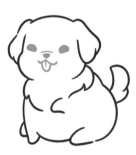

8. Finish by giving your doggy a playful facial expression.

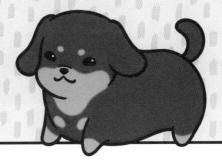

DACHSHUND

1. Draw the top of the head and the floppy ears pointing out.

2. Draw both sides of the head with a curved left cheek.

3. Draw the front and back of the body.

4. Extend the line of the back of the body into the outer-back leg. Add the inner-front leg and the looped tail.

5. Complete the body by drawing the underside. Add the outer-front leg.

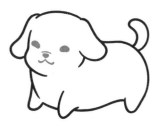

6. Finish by giving your doggy a content facial expression.

MALTESE

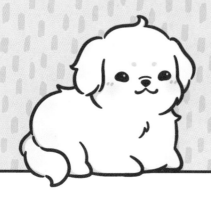

1. Draw the top of the head with a tuft of fur standing up.

2. Draw the floppy left ear and the partial right ear with fur detail.

3. Draw both sides of the head with fur detail on the right side.

4. Draw the front and back of the body with fur detail close to the head.

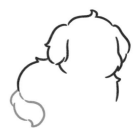

5. Wrap the furry tail around the base of the body.

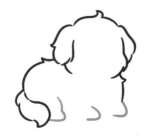

6. Draw the outer-back leg with an extended line to define the haunch. Add the front legs.

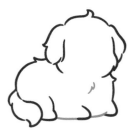

7. Complete the body by drawing the underside. Add a tuft of fur at the center of the chest.

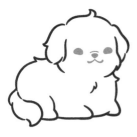

8. Finish by giving your doggy a content facial expression.

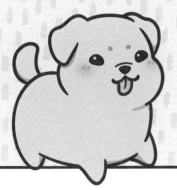

LABRADOR RETRIEVER

1. Draw the top of the head, the floppy left ear, and the partial right ear.

2. Draw both sides of the head with a curved right cheek.

3. Draw the front and back of the body and the outer-back leg. Add the inner-front leg.

4. Complete the body by drawing the underside. Add the outer-front leg and the looped tail.

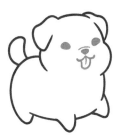

5. Finish by giving your doggy a playful facial expression.

CHOW CHOW

1. Draw the top of the head and the pointy ears slightly tilted to the left.

2. Draw both sides of the head with a curved right cheek.

3. Add some fur detail to the neck.

4. Place the fluffy tail "behind" the left side of the head.

5. Draw the back of the body, extending the line into the outer-back leg.

6. Draw the front of the body, extending the line into the inner-front leg. Add the outer-front leg.

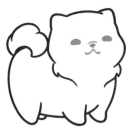

7. Complete the body by drawing the underside. Add the inner-back leg.

8. Finish by giving your doggy a content facial expression.

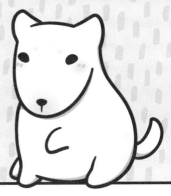

BULL TERRIER

1. Draw the top of the head and the pointy ears slightly tilted to the right.

2. Draw the head as an elongated U shape, starting at the left ear.

3. Draw the front of the body and the inner-front leg.

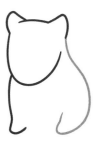

4. Draw the back of the body from the right ear and the outer-back leg.

5. Complete the body by drawing the underside. Add the inner-back leg and a raised outer-front leg. Draw the looped tail.

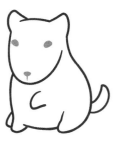

6. Finish by giving your doggy eyes and a nose with rounded triangles and adding a short, vertical line off the nose.

BOXER

1. Draw the top of the head, the floppy right ear, and the partial left ear.

2. Draw the left side of the head with a curved cheek.

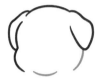

3. Draw the right side of the head and a short, curved line for the chin.

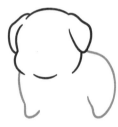

4. Draw the front and back of the body and the inner-front and outer-back legs.

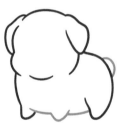

5. Complete the body by drawing the underside, the outer-front leg, and a rounded tail.

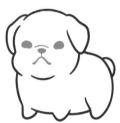

6. Give your doggy as content a facial expression as possible with those jowls.

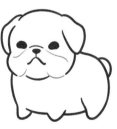

7. Finish by drawing thin lines to define the face folds.

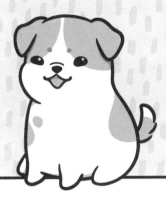

JACK RUSSELL TERRIER

1. Draw the top of the head and the floppy ears.

2. Draw both sides of the head with a curved left cheek.

3. Draw the front and back of the body and the inner-front leg.

4. Extend the line of the back of the body into the outer-back leg. Add the inner-back leg and the fluffy tail.

5. Complete the body by drawing the underside. Add the outer-front leg.

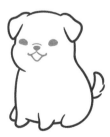

6. Finish by giving your doggy a playful facial expression.

GREAT DANE

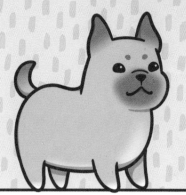

1. Draw the top of the head and the pointy ears.

2. Draw both sides of the head with a curved right cheek.

3. Draw the back of the body.

4. Extend the line of the back of the body into the outer-back leg. Draw the front of the body and add the inner-front leg.

5. Complete the body by drawing the underside. Add the outer-front leg.

6. Add the inner-back leg and the looped tail.

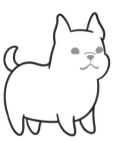

7. Finish by giving your doggy a content facial expression.

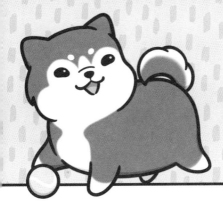

SIBERIAN HUSKY

1. Draw the top of the head and the pointy ears tilted to the left.

2. Draw both sides of the head with a curved right cheek and fur detail on the left side.

3. Place the fluffy tail "behind" the right side of the head.

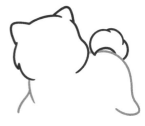

4. Draw the front and back of the body and the outer-back leg. Draw the top of the inner-front leg off the line of the front of the body.

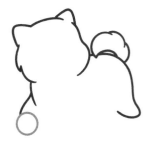

5. Draw a circle for the tennis ball at the base of the inner-front leg.

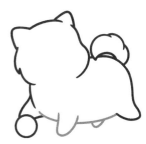

6. Complete the body by drawing the underside. Add the outer-front and inner-back legs.

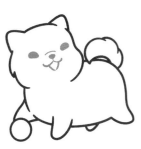

7. Finish by giving your doggy a playful facial expression.

PUG

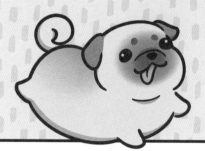

1. Draw the top of the head and the floppy ears tilted to the left.

2. Draw both sides of the head with a curved right cheek. Add a short, curved line for the chin.

3. Draw the back of the body from the left ear and the outer-back leg. Add the inner-front leg below the right side of the head.

4. Add the curled tail.

5. Complete the body by drawing the underside. Add the outer-front leg.

6. Finish by giving your doggy a playful facial expression.

FRENCH BULLDOG

1. Draw the top of the head and the pointy ears.

2. Draw the right side of the head with a curved cheek.

3. Draw the back of the body from the top of the head.

4. Extend the line of the back of the body into the outer-back leg and the underside of the body.

5. Add the front legs and short, curved lines for the left cheek.

6. Finish by giving your doggy a sleepy facial expression. Add a thin, curved line to define the snout.

BERNESE MOUNTAIN DOG

1. Draw the top of the head and the tops of the floppy ears.

2. Complete the ears with fur detail.

3. Draw the left side and bottom of the head.

4. Draw the front and back of the body, adding a little fur detail at the neck. Add the partial looped tail.

5. Add fur detail to complete the tail and the front and back of the body.

6. Add the outer-back and inner-front legs.

7. Complete the body by drawing the underside. Add the outer-front leg.

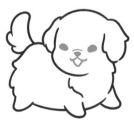

8. Finish by giving your doggy a playful facial expression.

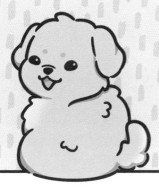

MALTIPOO

1. Draw the top of the head with a tuft of fur pointing left.

2. Draw the floppy ears.

3. Draw the left side of the head with a curved cheek.

4. Add some fur detail to the neck.

5. Draw the front and back of the body, adding a small bump to the top of the back of the body.

6. Add the fluffy tail.

7. Complete the body by drawing the underside. Add some fur detail to the body.

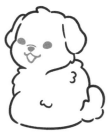

8. Finish by giving your doggy a playful facial expression.

CAVALIER KING CHARLES SPANIEL

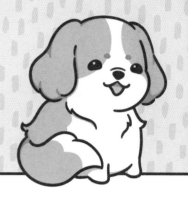

1. Draw the top of the head and the tops of the ears.

2. Complete the floppy ears with fur detail.

3. Draw the front and back of the body with spiky fur detail. Extend the line of the front of the body into the inner-front leg.

4. Wrap the furry tail along the base of the body.

5. Complete the body by drawing the underside. Add the outer-front leg and some fur detail at the neck.

6. Finish by giving your doggy a playful facial expression.

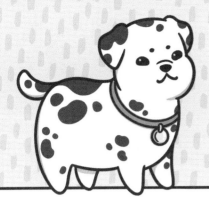

DALMATIAN

1. Draw the top of the head and the floppy ears slightly tilted to the left.

2. Draw both sides of the head with a curved right cheek.

3. Draw the back of the body and the outer-back leg.

4. Draw the front of the body. Add the inner-front leg.

5. Add the outer-front leg and the looped tail.

6. Complete the body by drawing the underside. Add the inner-back leg.

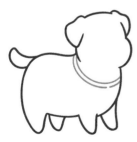

7. Draw parallel curved lines around the neck for the collar, leaving a small opening in the front of the lower line for the tag.

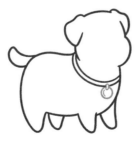

8. Draw a round tag with a clasp to fill the open space of the collar. Add a curved line inside the tag to give it depth.

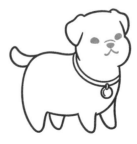

9. Finish by giving your doggy a content facial expression.

BOSTON TERRIER

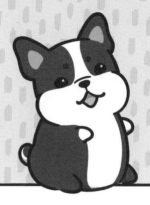

1. Draw the top of the head and the pointy ears tilted to the left.

2. Draw short lines for the tops of the sides of the head.

3. Complete the sides of the head with curved cheeks.

4. Draw the front and back of the body.

5. Add the outer-back leg and the rounded tail.

6. Complete the body by drawing the underside. Add the front legs and the inner-back leg.

7. Finish by giving your doggy a playful facial expression.

AFGHAN HOUND

1. Draw a long wavy line for the left ear with a shorter curved line inside.

2. Draw a shorter wavy right ear with a curved tip, also with a shorter curved line inside.

3. Extend wavy lines from the shorter curved lines to add more fur to the ears.

4. Draw a curved line for the bottom of the head. Add short hair lines at the top of the head below the curves of the ears.

5. Draw a short line on the left side for the front of the body. Add the looped tail, making the end pointy.

6. Draw the back of the body with fur detail and the outer-back leg.

7. Complete the body by drawing the underside with lots of fur detail.

8. Add the rounded front legs.

9. Finish by giving your doggy a content facial expression.

MINIATURE SCHNAUZER

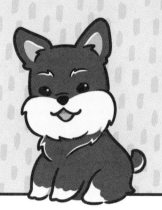

1. Draw the top of the head and the pointy ears slightly tilted to the left.

2. Draw both sides of the head with curved cheeks and fur detail.

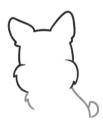

3. Draw the front and back of the body, adding fur detail to the front. Add the little looped tail.

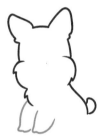

4. Draw the front legs, making them chonky.

5. Extend the line of the back of the body into a furry haunch.

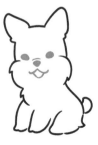

6. Give your doggy a playful facial expression.

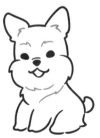

7. Finish by adding fur detail to the ears, eyebrows, and neck.

BEAGLE

1. Draw the top of the head and the floppy ears slightly tilted to the left.

2. Draw both sides of the head with a curved right cheek.

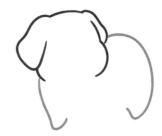

3. Draw the front and back of the body and the inner-front and outer-back legs.

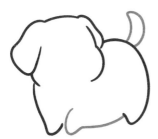

4. Complete the body by drawing the underside and the outer-front leg. Add the looped tail.

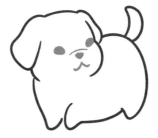

5. Finish by giving your doggy a content facial expression.

SHIBA INU

1. Draw the top of the head and the pointy ears slightly tilted to the left.

2. Draw both sides of the head with a curved left cheek.

3. Center the knot of the neckerchief below the head. Draw it as a circle with a leaf shape coming off each side.

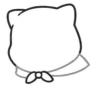

4. Draw the sides of the neckerchief with the top lines following the shape of the base of the head and the bottom lines slightly curving off the sides of the knot. Connect the top and bottom lines.

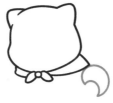

5. Add the tail in the shape of a crescent moon below the right side of the neckerchief.

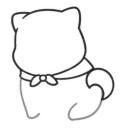

6. Draw the front and back of the body and the inner-front and outer-back legs.

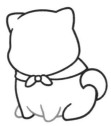

7. Complete the body by drawing the underside. Add the outer-front and inner-back legs.

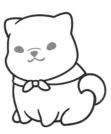

8. Finish by giving your doggy a content facial expression.

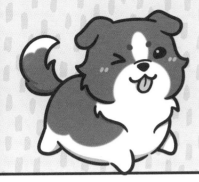

SAMOYED BORDER COLLIE MIX

1. Draw the top of the head and the floppy ears slightly tilted to the left.

2. Draw both sides of the head with spiky fur detail.

3. Add some fur detail around the neck.

4. Draw the front and back of the body and the outer-back leg.

5. Add the inner-front leg and the fluffy tail.

6. Complete the body by drawing the underside. Add the outer-front leg.

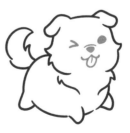

7. Finish by giving your doggy a playful facial expression with a wink.

CORGI

1. Draw the top of the head and the pointy ears tilted to the right.

2. Draw the left side of the head with a curved cheek and fur detail on the right side.

3. Add some fur detail to the neck.

4. Draw the rounded sides of the body.

5. Complete the body by drawing the underside. Add the back legs, pointing in, and the puffy tail.

6. Finish by giving your doggy a content facial expression.

PAPILLON

1. Draw the top of the head and the tops of the rounded pointy ears slightly tilted to the right.

2. Complete the ears with fur detail.

3. Draw both sides of the head with a curved right cheek and fur detail on the left side.

4. Place the fluffy tail "behind" the left side of the head.

5. Draw the back of the body and the outer-back leg. Add the inner-front leg below the right cheek.

6. Complete the body by drawing the underside. Add the inner-back and outer-front legs.

7. Finish by giving your doggy a playful facial expression.

GERMAN SHEPHERD

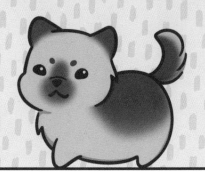

1. Draw the top of the head and the pointy ears slightly tilted to the right.

2. Draw both sides of the head with a curved left cheek and fur detail on the right side.

3. Draw the front and back of the body, adding fur detail to the chest. Extend the line of the back of the body into the outer-back leg.

4. Add the fluffy tail.

5. Complete the body by drawing the underside. Add the outer-front leg.

6. Finish by giving your doggy a content facial expression.

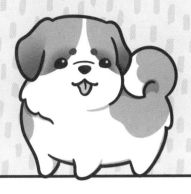

SAINT BERNARD

1. Draw the top of the head, the floppy left ear, and the partial right ear.

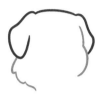

2. Draw the right side of the head with a curved cheek. Add fur detail to the neck on the left side.

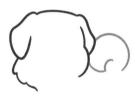

3. Place the curled tail "behind" the right side of the head.

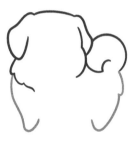

4. Draw the front and back of the body and the inner-front and outer-back legs.

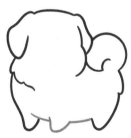

5. Complete the body by drawing the underside. Add the outer-front leg.

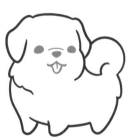

6. Finish by giving your doggy a playful facial expression.

BICHON FRISE

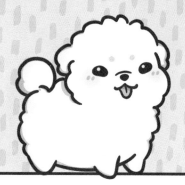

1. Draw the top of the head with curly fur.

2. Draw the furry ears.

3. Draw both sides of the head with fur detail.

4. Place the curled tail "behind" the left side of the head.

5. Draw the front and back of the body with curly fur.

6. Extend the lines from the front and back of the body into the outer-back and inner-front legs.

7. Complete the body by drawing the underside. Add the outer-front leg.

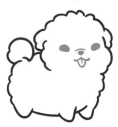

8. Finish by giving your doggy a playful facial expression.

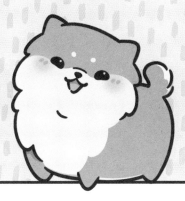

POMERANIAN

1. Draw the top of the head and the pointy ears tilted to the right.

2. Draw both sides of the head with lots of fur detail.

3. Draw the front of the body with fur detail. Place the fluffy tail "behind" the right side of the head. Add a short, curved line to define the chin.

4. Draw the back of the body around the tail and the outer-back leg.

5. Complete the body by drawing the underside. Add the front legs.

6. Finish by giving your doggy a playful facial expression.

AMERICAN STAFFORDSHIRE TERRIER

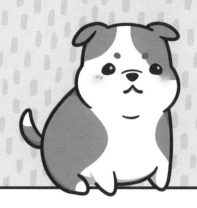

1. Draw the top of the head and the floppy ears.

2. Draw both sides of the head with curved lines for cheeks.

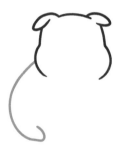

3. Draw the back of the body and the outer-back leg.

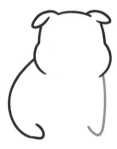

4. Draw the front of the body and the inner-front leg.

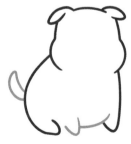

5. Complete the body by drawing the underside. Add the outer-front leg and the looped tail.

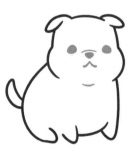

6. Finish by giving your doggy a content facial expression and draw a short, curved line for the chin.

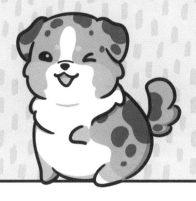

AUSTRALIAN SHEPHERD

1. Draw the top of the head, the floppy right ear, and the partial left ear.

2. Draw both sides of the head with fur detail.

3. Add some fur detail around the neck.

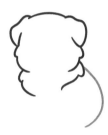

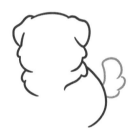

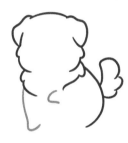

4. Draw the back of the body.

5. Add the fluffy tail.

6. Draw the front of the body and the inner-front leg. Add the outer-front leg raised.

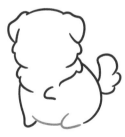

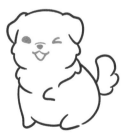

7. Complete the body by drawing the underside. Add the outer-back leg.

8. Finish by giving your doggy a playful facial expression with a wink.

ENGLISH BULLDOG

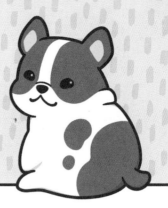

1. Draw the top of the head and the pointy ears slightly tilted to the right.

2. Draw the left side of the head with a curved cheek.

3. Draw the right side of the head with a short line. Add a sideways U shape off this line for the roll at the back of the head.

4. Draw the front of the body.

5. Draw the back of the body. Add the looped tail.

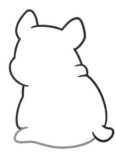

6. Complete the body by drawing the underside and the outer-back leg.

7. Finish by giving your doggy a content facial expression.

CHIHUAHUA

1. Draw the top of the head and the pointy ears slightly tilted to the left.

2. Extend the spiky fur detail from the ears.

3. Draw both sides of the head.

. .

4. Add the front legs, pointing to the right, below the head.

5. Draw the front and back of the body.

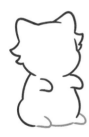

6. Complete the body by drawing the underside. Add the back legs.

. .

7. Add the fluffy tail.

8. Finish by giving your doggy a playful facial expression and some fur detail in the ears.

POODLE

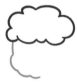

1. Start the top of the head with curly fur.

2. Complete the top of the head, giving it a cloudlike shape.

3. Draw the left side and the bottom of the head with curly fur.

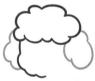

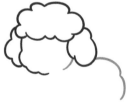

4. Add the floppy ears, also with curly fur detail.

5. Add a curved line for the right side of the head. Draw the back of the body.

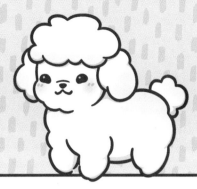

6. Extend a line from the back of the body for the chonky outer-back leg. Draw the front of the body and the chonky inner-front leg.

7. Add the puffy tail.

8. Complete the body by drawing the underside. Add the chonky outer-front leg.

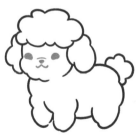

9. Finish by giving your doggy a content facial expression.

ROTTWEILER

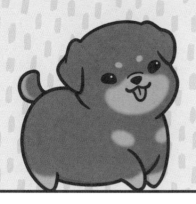

1. Draw the top of the head and the floppy ears tilted to the left.

2. Draw both sides of the head.

3. Draw the front and back of the body and the outer-back and inner-front legs.

4. Add the looped tail.

5. Complete the body by drawing the underside. Add the outer-front leg.

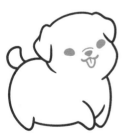

6. Finish by giving your doggy a playful facial expression.

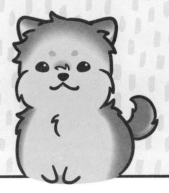

YORKSHIRE TERRIER

1. Draw the top of the head with a tuft of fur pointing to the left and the pointy ears.

2. Draw both sides of the head with spiky fur detail.

3. Continue drawing the sides of the head with curved, furry cheeks.

4. Add spiky fur detail to the neck and chest.

5. Draw the front and back of the body.

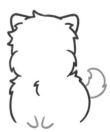

6. Center the front legs at the base of the body, slightly pointing in. Add the fluffy tail.

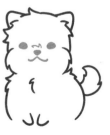

7. Finish by giving your doggy a content facial expression.

PUPPIES

Every day may not be good . . .

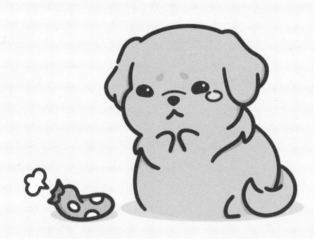

. . . but there is something good in every day.

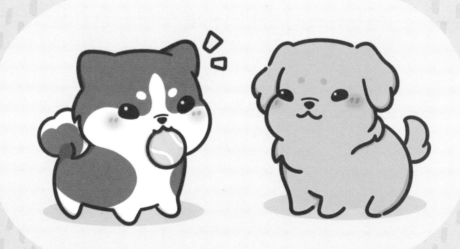

FRENCH BULLDOG

1. Draw the top of the head and the pointy ears.

2. Draw both sides of the head with a curved left cheek.

3. Draw the front and back of the body and the inner-front leg.

4. Add the outer-front and -back legs and the looped tail.

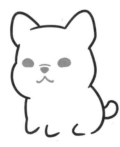

5. Finish by giving your doggy a content facial expression.

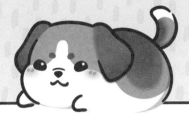

BEAGLE

1. Draw the top of the head, the floppy right ear, and the partial left ear.

2. Draw the left side of the head with a curved cheek.

3. Draw the back of the body from the right ear.

4. Add the front legs below the head and the looped tail.

5. Finish by giving your doggy a content facial expression.

MINIATURE SCHNAUZER

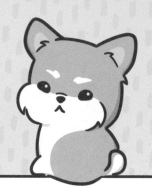

1. Draw the top of the head and the pointy ears tilted to the right.

2. Draw the right side of the head, with a tuft of fur, and a short line for the left side of the head.

3. Add cheeks with fur detail.

4. Draw the front and back of the body and the outer-front leg.

5. Complete the body by drawing the underside. Add the looped tail.

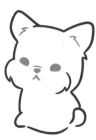

6. Finish by giving your doggy a serious facial expression and fur detail in the ears.

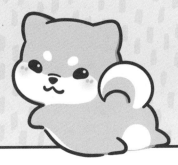

SHIBA INU

1. Draw the top of the head and the pointy ears slightly tilted to the right.

2. Draw the left side of the head with a curved cheek and a short line for the right side.

3. Place the curled tail so that it fills in the right side of the head.

4. Draw the back of the body and the inner-back leg. Add the outer-front leg below the left side of the head.

5. Complete the body by drawing the underside. Add the outer-back leg.

6. Finish by giving your doggy a content facial expression.

SIBERIAN HUSKY

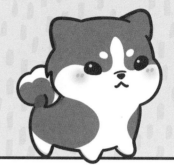

1. Draw the top of the head and the pointy ears.

2. Draw both sides of the head with a curved right cheek and spiky fur detail on the left side.

3. Place the curled tail "behind" the left side of the head.

4. Draw the front and back of the body and the inner-front and outer-back legs.

5. Complete the body by drawing the underside. Add the outer-front leg.

6. Finish by giving your doggy a serious facial expression.

MALTESE

1. Draw the top of the head, with a tuft of fur sticking up, tilted to the left.

2. Draw the outsides of the floppy ears with fur detail on the right side.

3. Complete the ears with fur detail.

4. Draw the left side of the head with a curved cheek.

5. Place the front legs, pointing in, just below the head. Add the outer-back leg, pointing up, below the front legs.

6. Add the fluffy tail off the back leg.

7. Draw the back of the body with fur detail.

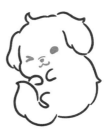

8. Finish by giving your doggy a playful facial expression with a wink.

PAPILLON

1. Draw the top of the head and the tops of the rounded pointy ears.

2. Complete the ears with fur detail.

3. Draw both sides of the head with a curved left cheek and fur detail on the right side.

4. Draw the front and back of the body. Add the outer-front leg at the base of the right side of the body.

5. Wrap the fluffy tail along the base of the body.

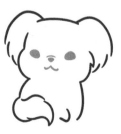

6. Finish by giving your doggy a content facial expression.

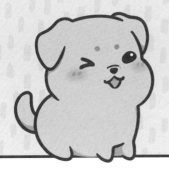

LABRADOR RETRIEVER

1. Draw the top of the head, the floppy left ear, and the partial right ear.

2. Draw both sides of the head with a curved right cheek.

3. Draw the front and back of the body and the inner-front and outer-back legs.

4. Add the outer-front leg and the looped tail.

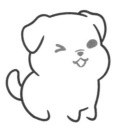

5. Finish by giving your doggy a playful facial expression with a wink.

PUG

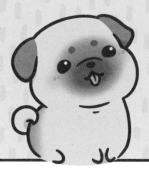

1. Draw the top of the head, the floppy left ear, and the partial right ear tilted to the left.

2. Draw the right side of the head with a curved cheek.

3. Draw the left side of the head and a short, curved line to define the chin. Add a dash of a line below the chin line.

4. Draw the front of the body and a short, curved line for the start of the back of the body.

5. Add the curled tail below the short, curved line.

6. Complete the body by drawing the remaining back of the body. Add the outer-back and the front legs.

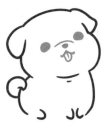

7. Finish by giving your doggy a playful facial expression.

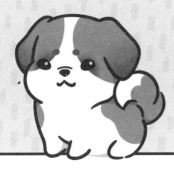

SAINT BERNARD

1. Draw the top of the head, the floppy right ear, and the partial left ear.

2. Draw the left side of the head with a curved cheek.

3. Place the fluffy tail "behind" the right ear.

4. Draw the front and back of the body and the inner-front and outer-back legs.

5. Complete the body by drawing the underside. Add the outer-front leg and a line off the tail to define the right side of the neck.

6. Finish by giving your doggy a content facial expression.

POSES & MOODS

Don't just dream of greatness.

Chase it!

STAND! (FRONT)

1. Draw the top of the head and the pointy ears.

2. Draw both sides of the head with a curved left cheek.

3. Draw the front of the body with fur detail at the neck. Extend the line into the inner-front leg.

4. Place the curled tail "behind" the right side of the head.

5. Draw the back of the body and the outer-back leg.

6. Complete the body by drawing the underside. Add the outer-front leg.

7. Finish by giving your doggy a content facial expression.

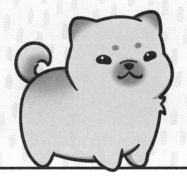

STAND! (SIDE)

1. Draw the top of the head and the pointy ears slightly tilted to the left.

2. Draw both sides of the head with a curved right cheek.

3. Draw the back of the body and the outer-back leg.

4. Draw the front of the body with fur detail at the neck. Extend the line into the inner-front leg.

5. Complete the body by drawing the underside. Add the outer-front leg.

6. Add the fluffy tail.

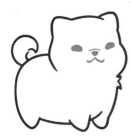

7. Finish by giving your doggy a content facial expression.

STAND! (BACK)

1. Draw the looped tail.

2. Draw a curved line around the top of the tail for the top of the head.

3. Add the pointy ears.

4. Draw both sides of the head.

5. Draw equally curved lines from the sides of the tail for the back of the body.

6. Extend the lines of the back of the body into the back legs.

7. Complete the body by drawing the underside. Finish by drawing an X for, well, you know.

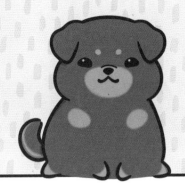

SIT! (FRONT)

1. Draw the top of the head.

2. Add the floppy ears.

3. Draw both sides of the head with curved lines for cheeks.

4. Draw the sides of the body.

5. Center the front legs, pointing in, at the base of the body. Draw the back legs, pointing out, off the sides of the body.

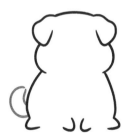

6. Add the looped tail.

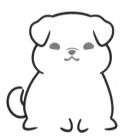

7. Finish by giving your doggy a content facial expression.

SIT! (SIDE)

1. Draw the floppy left ear.

2. Draw the top of the head and the partial right ear.

3. Draw both sides of the head with a curved right cheek.

4. Draw the front of the body with fur detail at the neck. Extend the line into the inner-front leg.

5. Draw the back of the body and the outer-back leg.

6. Complete the body by drawing the underside. Add the outer-front leg and the looped tail.

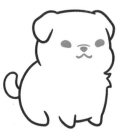

7. Finish by giving your doggy a content facial expression.

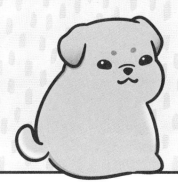

SIT! (BACK)

1. Draw the floppy left ear.

2. Draw the top of the head and the partial right ear.

3. Draw the right side of the head with a curved cheek.

4. Draw the back of the body from the center of the left ear.

5. Draw the front of the body. Add the looped tail.

6. Complete the body by drawing the underside. Add the outer-front leg.

7. Finish by giving your doggy a content facial expression.

LIE DOWN! (FRONT)

1. Draw the top of the head.

2. Add the pointy ears.

3. Draw both sides of the head with curved lines for cheeks.

4. Draw small ovals, pointing in, at the base of the head for the front paws.

5. Center the curled tail above the head.

6. Draw curved lines around the tail and ears for the back of the body.

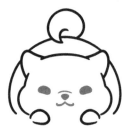

7. Finish by giving your doggy a content facial expression.

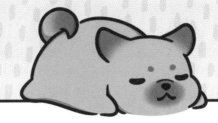

LIE DOWN! (SIDE)

1. Draw the top of the head and the pointy left ear.

2. Add the right ear. Draw a curved line off the top of the head for the start of the back of the body.

3. Draw the right side of the head with a curved cheek.

4. Add the curled tail.

5. Continue drawing the back of the body, extending the line into the outer-back leg.

6. Complete the body by drawing the underside. Add the front legs.

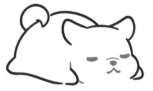

7. Finish by giving your doggy a sleepy facial expression and drawing the left side of the face.

LIE DOWN! (BACK)

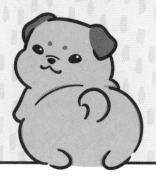

1. Draw the floppy right ear.

2. Draw the top of the head and the partial left ear tilted to the right.

3. Draw both sides of the head with a curved left cheek.

4. Draw the front-left leg, the top of the front-right leg, and a thin, curved line below the neck for the top of the back of the body.

5. Complete the back of the body with equally curved lines.

6. Add the back legs, pointing in, and the looped tail, making the end pointy.

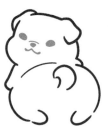

7. Finish by giving your doggy a content facial expression.

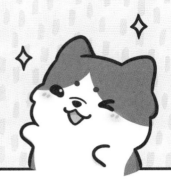

HAPPY

1. Draw the top of the head and the pointy ears tilted to the right.

2. Draw the left side of the head with fur detail.

3. Draw the right side of the head, also with fur detail.

4. Draw the front legs, pointing up, right below the head.

5. Draw short lines for the sides of the body. Add a couple of diamond sparkles around the head to express happiness.

6. Finish by giving your doggy a playful facial expression with a wink.

SAD

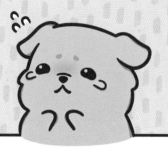

1. Draw the top of the head and the floppy ears slightly tilted to the right.

2. Draw both sides of the head with fur detail.

3. Draw short lines for the sides of the body. Center the front paws, pointing in, below the head.

4. Give your doggy a sad facial expression.

5. Finish by drawing tears on the face and around the head in small U shapes.

1. Draw the top of the head and the pointy ears slightly tilted to the left.

2. Draw both sides of the head with fur detail.

3. Draw short lines for the sides of the body. Add a couple of small trapezoidal shapes around the head to express an angry barking sound.

4. Give your doggy an angry facial expression, starting with the eyes and nose.

5. Finish by drawing an open, barking mouth in a simple house-like shape with a fang in the top-left corner.

HUNGRY

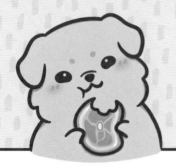

1. Draw the top of the head and the floppy ears tilted to the left.

2. Draw both sides of the head with fur detail.

3. Draw short lines for the sides of the body. Center the front paws, pointing in, below the head.

4. Draw the steak with a large bite taken out of it between the paws so that they are "holding" it.

5. Finish by giving your doggy a content facial expression. Draw a curved line off the left side of the mouth to define a cheek full of food.

SURPRISED

1. Draw the top of the head as a spiky tuft of fur tilted to the right.

2. Add the pointy ears.

3. Draw the left side of the head with fur detail.

4. Draw the right side of the head, also with fur detail.

5. Draw a short, curved line for the left side of the body. Add the front legs, pointing up and to the right, below the head.

6. Draw circles for the eyes and a few vertical lines below the right ear to express surprise.

7. Complete your doggy's surprised facial expression. Finish by drawing a couple of sweat droplets in small U shapes.

EMBARRASSED

1. Draw the top of the head, the floppy right ear, and the partial left ear slightly tilted to the left.

2. Draw both sides of the head with fur detail on the right side.

3. Add the front legs, pointing up, as if covering eyes.

4. Draw short lines for the sides of the body. Add short, diagonal lines right above and between the legs to express embarrassment.

5. Finish by giving your doggy a content facial expression (despite their embarrassment).

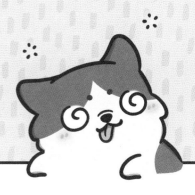

DIZZY

1. Draw the top of the head and the pointy ears tilted to the left.

2. Draw the left side of the head with fur detail and a short line for the right side of the head.

3. Add fur detail to the right side of the head. Extend a short line from the right side of the head for the body.

4. Add the front legs, pointing to the left, below the head. Draw a couple of star-like shapes above the head to express dizziness.

5. Draw spirals for the eyes.

6. Finish by giving your doggy a playful facial expression.

CURIOUS

1. Draw the top of the head and the floppy left ear tilted to the right.

2. Add the right ear. Draw the left side of the head with fur detail.

3. Draw the right side of the head, also with fur detail.

4. Extend a short line from the left side of the head for the body. Add the right leg pointing up and to the left. Place a question mark above the head to express curiosity.

5. Finish by giving your doggy a thoughtful facial expression.

EXASPERATED

1. Draw the top of the head and the pointy ears.

2. Draw both sides of the head with a curved left cheek and fur detail on the right.

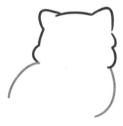

3. Draw the front and back of the body.

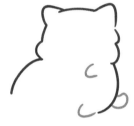

4. Add the outer-front and -back legs, pointing in, on the right side of the body and the looped tail.

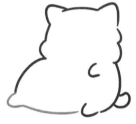

5. Complete the body by drawing the underside. Add the inner-back leg.

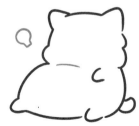

6. Draw a thin, curved line to define the top of the belly. Add a shape like a lightbulb to the left of the head to express exasperation.

7. Finish by giving your doggy an annoyed facial expression.

DAILY ACTIVITIES

I love doing yoga . . .

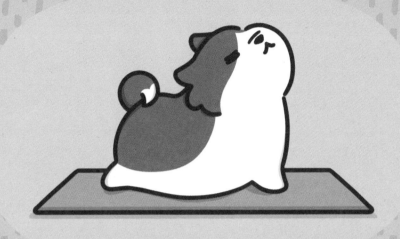

. . . especially this pose.

DREAMING

1. Draw the top of the head and the pointy ears tilted sideways.

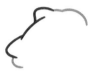

2. Draw both sides of the head with a curved right cheek.

3. Draw the back of the body off the right side of the head.

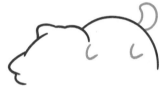

4. Add the outer-front and -back legs and the looped tail.

5. Draw a thin, curved line on the left side of the head and a thicker line below it to show the head "smooshed" against the floor. Add the inner-front leg below the left side of the head.

6. Complete the body by drawing the underside and the inner-back leg kicked out.

7. Finish by giving your doggy a sleepy facial expression with a large drop of drool coming out of the mouth.

SCRATCHING

1. Draw the top of the head and the pointy ears tilted to the left.

2. Draw both sides of the head with a curved left cheek and fur detail on the right side.

3. Draw the front of the body and the inner-front leg.

4. Draw the back of the body. Add the outer-front leg and a short, curved line for the underside of the body.

5. Draw the back legs together, pointing up and to the left, near the center of the body. Add a couple of curved lines above the back legs to express the action of scratching.

6. Finish by giving your doggy a content facial expression with a wink.

GREETING

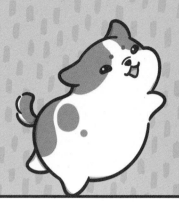

1. Draw the top of the head and the pointy right ear tilted to the left.

2. Add the left ear with a short, curved line coming off the bottom.

3. Draw the right side of the head with a curved cheek.

4. From the short, curved line below the left ear, draw the back of the body and the outer-back leg.

5. Complete the body by drawing the underside. Add the outer-front leg.

6. Add the inner-back leg and the fluffy tail.

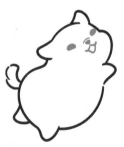

7. Finish by giving your doggy a playful facial expression.

1. Draw the top of the head and the pointy ears.

2. Draw both sides of the head with a curved left cheek.

3. Add the front legs at either side of the base of the head. Place the curled tail above the right ear.

4. Draw the back of the body around the tail.

5. Give your doggy a focused facial expression.

6. Finish by having your doggy "biting" a piece of cloth. Draw the cloth with a smaller upside-down U shape inside a larger upside-down U shape.

CHASING

1. Draw the curved snout and the left side of the head.

2. Draw the right side of the head and the pointy ears pointing back.

3. Draw a short curve for the top of the back of the body. Add the looped tail and outer-front leg.

4. Continue drawing the back of the body below the tail, extending the line into the inner-back leg.

5. Complete the body by drawing the front and underside. Add the outer-back leg.

6. Give your doggy eyes and a nose with rounded triangles and add a thin, curved line above the nose.

7. Finish by drawing the butterfly above your doggy's snout.

SLEEPING

1. Draw the top of the head and the pointy ears slightly tilted to the left.

2. Draw both sides of the head with a curved right cheek and fur detail on the left side.

3. Draw the back of the body from the top of the head.

4. Add the front legs at either side of the base of the head. Wrap the looped tail with a pointy tip along the base of the body.

5. Give your doggy a sleepy facial expression.

6. Draw the back and left side of the cushion with rounded corners around your doggy.

7. Finish by drawing the front and right side of the cushion.

PLAYING

1. Draw the top of the head and the pointy ears tilted to the left.

2. Draw both sides of the head with a curved right cheek and fur detail on the left side.

3. Draw the back of the body.

4. Add the front legs below the head and the outer-back leg kicking up.

5. Draw the front of the body and the inner-back leg kicking up.

6. Complete the body by drawing the underside. Add the looped tail.

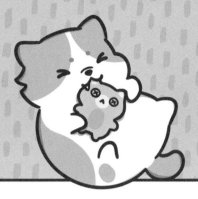

7. Give your doggy a playful facial expression with a fang peeking out of the mouth.

8. Draw the head of the stuffed toy between the mouth and inner-front leg.

9. Draw the body of the stuffed toy with short arms and legs.

10. Finish by giving the stuffed toy button-style eyes and an upside-down V shape for the nose.

BEING NAUGHTY

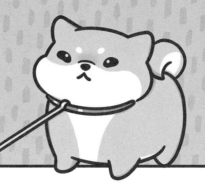

1. Draw the top of the head and the pointy ears slightly tilted to the right.

2. Draw both sides of the head with a curved left cheek.

3. Place the curled tail "behind" the right side of the head.

4. Draw the leash off the center of the base of the head with long, parallel lines that turn into a curved hook.

5. Draw the collar around the leash hook with the top lines following the shape of the base of the head and a curved bottom line. Connect the top and bottom lines.

6. Draw the front and back of the body and the inner-front and outer-back legs.

7. Complete the body by drawing the underside. Add the outer-front leg.

8. Finish by giving your doggy a vacant facial expression.

POOPING

1. Draw the top of the head and the pointy ears tilted to the right.

2. Draw the right side of the head with a curved cheek.

3. Draw the tops of the back of the body and the tail.

. .

4. Complete the furry tail and the back of the body.

5. Complete the body by drawing the front and underside. Draw the outer-front leg.

6. Add the outer-back leg with a line that defines the haunch.

. .

7. Draw the dropping below the tail with vertical action lines.

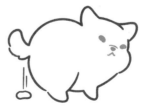

8. Finish by giving your doggy an annoyed facial expression.

CHEWING

1. Draw the top of the head and the pointy ears slightly tilted back and to the left.

2. Draw both sides of the head with a curved right cheek and fur detail on the left side.

3. Draw the back of the body.

4. Add the front legs, pointing up, below the head and the fluffy tail.

5. Draw the front of the body and the inner-front leg.

6. Complete the body by drawing the underside. Add the outer-front leg.

7. Give your doggy a content facial expression.

8. Finish by drawing the bone in your doggy's mouth, along with chewing and motion lines.

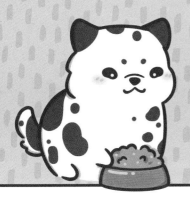

EATING

1. Draw the top of the head and the pointy ears.

2. Draw both sides of the head with a curved right cheek and fur detail on the left side.

3. Draw the front and back of the body.

4. Draw the outer-front and -back legs on the left side of the body with the front one a little higher. Add the fluffy tail.

5. Fill in the space on the right side of the body with the food bowl, placing it below the outer-front paw. Draw the bowl with curved, parallel lines. Connect the top and bottom lines.

6. Add a heaping pile of food to the bowl.

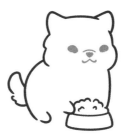

7. Finish by giving your doggy a content facial expression.

STRETCHING

1. Draw the top of the head and the pointy left ear tilted to the left.

2. Draw the curved snout. Add the right ear.

3. Draw the front of the body and the outer-front leg.

4. Place the curled tail "behind" the ears.

5. Draw the back of the body around the tail.

6. Complete the body by drawing the underside and the outer-back leg.

7. Give your doggy a serene facial expression.

8. Finish by drawing the yoga mat around your doggy with a partial rectangle.

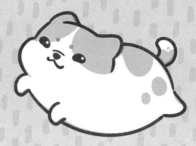

JUMPING

1. Draw the top of the head and the pointy ears tilted back and to the right.

2. Draw both sides of the head and add a curved left cheek.

3. Draw the back of the body and the outer-back leg pointing out.

4. Add the inner-front leg and the looped tail.

5. Complete the body by drawing the underside. Add the outer-front leg.

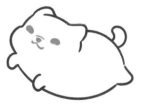

6. Finish by giving your doggy a content facial expression.

PRANCING

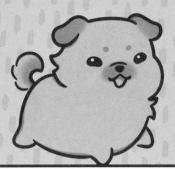

1. Draw the top of the head and the floppy ears.

2. Draw both sides of the head with a curved right cheek and fur detail on the left side.

3. Draw the front and back of the body with fur detail at the neck.

4. Add the outer-back and inner-front legs and the fluffy tail.

5. Complete the body by drawing the underside. Add the outer-front leg.

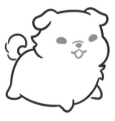

6. Finish by giving your doggy a playful facial expression.

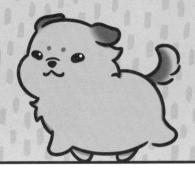

WALKING

1. Draw the top of the head and the floppy ears pointing back.

2. Draw both sides of the head with a curved left cheek and spiky fur detail on the right side.

3. Draw the back of the body and the outer-back leg.

4. Draw the front of the body with fur detail at the neck. Add the fluffy tail.

5. Complete the body by drawing the underside. Add the outer-front leg.

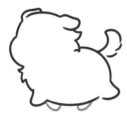

6. Add the inner legs between the outer legs.

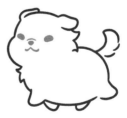

7. Finish by giving your doggy a content facial expression.

RUNNING

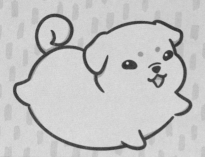

1. Draw the floppy left ear.

2. Draw the top of the head and the right ear slightly tilted to the left.

3. Draw both sides of the head with a curved right cheek.

4. Draw the back of the body and the outer-back leg.

5. Add the inner-front leg and the curled tail.

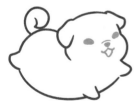

6. Complete the body by drawing the underside. Add the outer-front leg.

7. Finish by giving your doggy a playful facial expression.

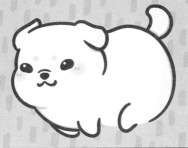

GALLOPING

1. Draw the top of the head and the floppy ears, with the left ear pointing back.

2. Draw both sides of the head with a curved left cheek.

3. Draw the back of the body.

4. Draw the front of the body and the outer-front leg.

5. Add the outer-back and inner-front legs and the looped tail.

6. Finish by giving your doggy a content facial expression.

DRESS-UP

You are guilty . . .

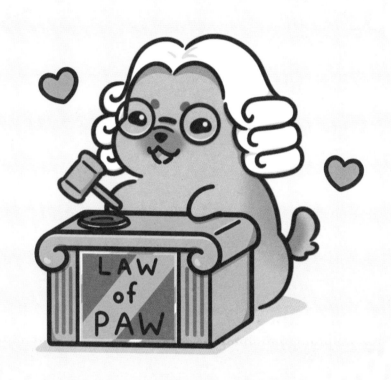

. . . of being too cute!

CANINE CLOWN

1. Draw the top of the clown wig with a cloudlike shape.

2. Complete the wig with more cloudlike shapes.

3. Draw the left side of the head with a curved cheek.

4. Complete the head with a curved line. Add the ruffled collar.

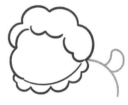

5. Draw the back of the body. Add the looped tail.

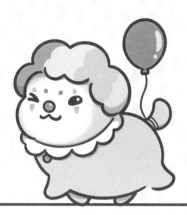

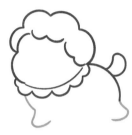

6. Extend the line of the back of the body into the outer-back leg. Draw the front of the body and the outer-front leg.

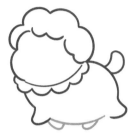

7. Complete the body by drawing the underside. Add the inner legs.

8. Draw the button off the center of the ruffled collar with a small circle. Give your doggy a content facial expression with a clown nose and a wink.

9. Finish your doggy by attaching the balloon to their tail, with the string wrapping around it a couple of times.

POOCHCASSO

1. Draw the beret as a bean shape with a loop on top.

2. Add the floppy ears off the sides of the beret. Draw the start of the left side of the head.

3. Complete the sides of the head with a curved right cheek.

4. Draw the back of the body and the outer-back leg.

5. Add the outer-front leg raised a bit and the fluffy tail.

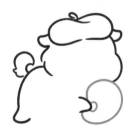

6. Draw the paint palette so that the outer-front leg is "holding" it. Add the partial circle inside the palette.

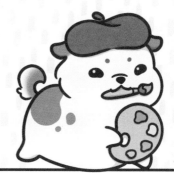

7. Draw little cloudlike shapes on the palette for the splats of paint.

8. Complete the body by drawing the underside. Add the inner-front leg.

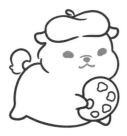

9. Give your doggy a content facial expression.

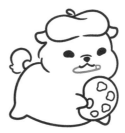

10. Draw the handle of the paintbrush so that your doggy's mouth is "holding" it.

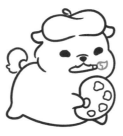

11. Finish by giving the paintbrush its bristles.

DOG DOG GOO GOO

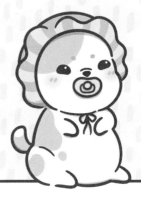

1. Draw the top and the left side of the head.

2. Draw the right side of the head with a curved cheek.

3. Draw the bonnet around the head with undulating lines.

4. Complete the head with a curved line and a bow coming off the bottom of it.

5. Draw the front and back of the body.

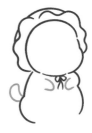

6. Draw the front legs, pointing in, on either side of the bow. Add the looped tail.

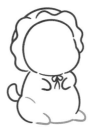

7. Complete the body by drawing the underside. Add the back legs, defining the outer haunch with a short, curved line.

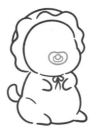

8. Add the pacifier in place of the mouth. Draw a wide heart shape for the base with a partial rectangle inside for the handle and a circle on top of that.

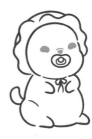

9. Finish by giving your doggy eyes and a nose.

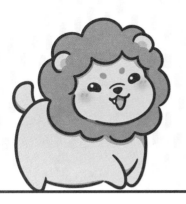

DOGLION

1. Draw the base of the mane with spiky fur detail slightly tilted to the left.

2. Draw the complete head with a curved right cheek.

3. Draw the round ears angled to the sides.

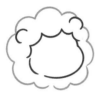

4. Complete the mane with a cloudlike shape going around the head.

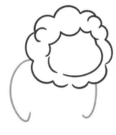

5. Draw the front and back of the body with the inner-front and outer-back legs.

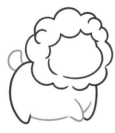

6. Complete the body by drawing the underside. Add the outer-front leg, a line to define the inner-front leg, and the looped tail.

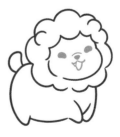

7. Finish by giving your doggy a playful facial expression with a fang peeking out of the mouth.

JUDGE DOGGY

1. Draw the back of the wig like an exaggerated mustache.

2. Draw similar curved lines for the front of the wig, extending the left line into a curved left cheek.

3. Add three rows of rolled curls to the left side of the wig. Add a short, curved line to each curl to give it definition.

4. Draw a wide rolled curl on the right side with a hook on the end of its left side.

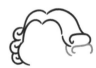

5. Draw another rolled curl below the first one.

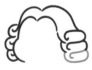

6. Draw a third and final rolled curl, closing the base of it.

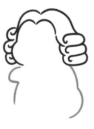

7. Draw the front and back of the body with the inner-front leg below the head.

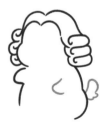

8. Add the outer-front leg and the fluffy tail.

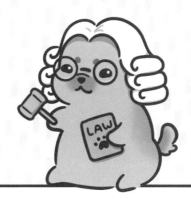

9. Complete the body by drawing the underside. Add the back legs.

10. Draw the law book as a partial rectangle so that the outer-front leg is "holding" it. Decorate the book cover however you like.

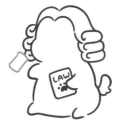

11. Place the top of the gavel at an angle above the inner-front leg, leaving room for the handle.

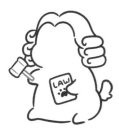

12. Draw the handle so that the inner-front leg is "holding" it.

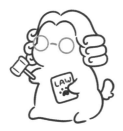

13. Add round glasses to your doggy's face.

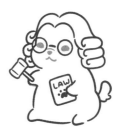

14. Finish by giving your doggy a content facial expression.

BON(E) APPÉTIT

I wish everything was as
easy as getting fat.

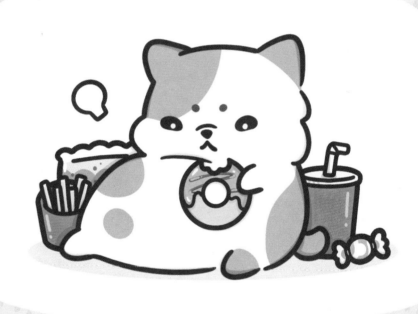

DOGGY MACARON

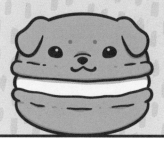

1. Draw the top of the head and the floppy ears.

2. Draw a short line below each ear that widens at the bottom. Connect these lines with a slightly curved line for the top shell of the cookie.

3. Draw short, curved lines slightly in from the sides of the top shell for the filling. Add the top and sides of the bottom cookie shell below the filling.

4. Complete the bottom cookie shell by drawing a rounded base.

5. Draw short and long dashes on the cookie shells to give the macaron some texture.

6. Finish by giving your macaron a content facial expression.

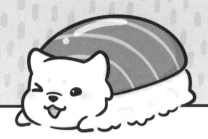

DOGIRI SUSHI

1. Draw the top of the head and the pointy ears.

2. Draw both sides of the head with a curved left cheek and fur detail on the right side.

. .

3. Draw a line for the base of the head. Add the front paws at either side of the base of the head.

4. Draw the top of the piece of fish like you would the back of a doggy.

5. Close up the piece of fish.

. .

6. Add the sushi rice below the piece of fish, making sure to include the outer-back leg.

7. Finish by giving your nigiri a playful facial expression with a wink.

DOGGY CONE

1. Draw the top of the head with the cherry in the center.

2. Add the floppy ears.

3. Draw both sides of the head equally rounded to mimic a scoop of ice cream.

4. Close up the bottom of the ice cream scoop with a line of drips.

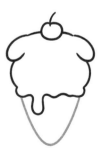

5. Draw a rounded V shape for the cone.

6. Finish by giving your ice cream cone a content facial expression.

PUPCAKE

1. Draw the top of the head and the pointy ears slightly tilted to the right.

2. Draw both sides of the head with a curved left cheek.

3. Draw the back of the body from the top of the head.

4. Draw the partial front legs with single quotation marks. Wrap the fluffy tail along the base of the body.

5. Draw a wide U shape below your doggy for the cupcake liner so that your doggy fits in it nice and cozy.

6. Give the cupcake liner a scalloped top.

7. Draw some vertical lines that slant toward the center of the cupcake liner to define its pleats.

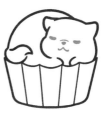

8. Finish by giving your cupcake a sleepy facial expression.

HOT DOG DOG

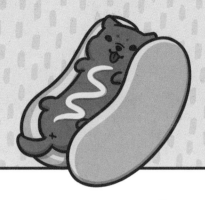

1. Draw the bottom curve of the outer bun tilted to the right.

2. Complete the outer bun with a line with a dip in the center.

3. Off the top of the bun, draw the top of your doggy's head and the pointy ears slightly tilted to the right.

4. Draw the left side of the head with a curved cheek.

5. Add the front legs below the base of the head. Add the outer-back leg farther down the bun.

6. Complete the body by drawing the left side, inner-back leg, and underside, leaving a space for the tail.

7. Add the looped tail with an X above for the, well, the casing.

8. Draw the other side of the bun around your doggy, following the same curve as the outer bun.

9. Finish by giving your hot dog a playful facial expression.

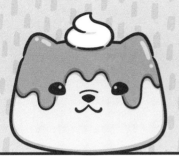

CRÈME CANINE

1. Draw the dollop of whipped cream with a round bottom and a pointed tip like a chocolate chip.

2. Draw the top of the head and the pointy ears around the base of the dollop so that the dollop is sitting on the top of the head.

3. Draw lines that curve and widen at the bottom from the base of each ear for the sides of the crème caramel.

4. Close up the base of the crème caramel with a curved line.

5. Give your crème caramel a content facial expression.

6. Finish by drawing dripping caramel around the top half of the dessert and the eyes.

POOCHCAKE

1. Draw three sides of the pat of butter angled to the right, curving in the ends to add dimension.

2. Finish the butter pat with a few more lines to add even more dimension.

3. Draw dripping syrup around the butter.

4. Draw the top of the head and the floppy ears of your doggy around the butter and syrup, slightly tilted to the right.

5. Draw a wide U shape for your doggy's head/pancake.

6. Add lines inside the bottom and right side of the pancake to give it some thickness.

7. Finish by giving your pancake a playful facial expression.

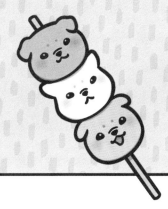

DOGGO

1. Draw the top of the head of the top doggy/dango and the floppy ears tilted to the left.

2. Complete the head with a wide U shape.

3. Draw the pointy ears for the middle doggy/dango.

4. Complete the head with a wide U shape.

5. Draw the floppy ears for the bottom doggy/dango.

6. Complete the head with a wide U shape.

7. Draw the stick "through" the center of the dango with parallel lines that connect at the top and bottom with short, curved lines.

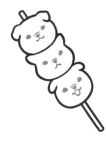

8. Finish by giving the top dango a content facial expression, the middle dango a serious expression, and the bottom dango a playful expression.

BAO-WOW

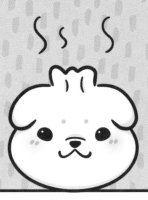

1. Draw the pinched top of the bao with larger curves on the sides and a smaller one in the middle.

2. Draw a floppy ear from the bottom of each side of the pinched top.

3. Draw the head/bao as a wide U shape.

4. Give your bao a content facial expression.

5. Finish by adding a couple of curved lines inside the pinched top and steam lines in S shapes above.

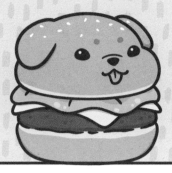

DOGGY CHEESEBURGER

1. Draw the top of the head and the floppy left ear.

2. Draw the sides of the head with a curved right cheek. Add the right ear as a curved line.

3. Draw a slightly curved line to complete the top bun.

4. Draw the lettuce below the bun with an undulating line. Add a few vertical lines for crease details.

5. Draw three rounded corners for the cheese slice peeking out below the lettuce.

6. Draw a curved line for the patty with short and long dashes.

7. Draw the bottom bun below the patty with a wide U shape.

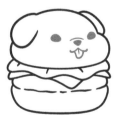

8. Finish by giving your cheeseburger a playful facial expression.

PORTRAITS

Having a bad day?

A smile is a curve that sets
everything straight.

AUSTRALIAN SHEPHERD

1. With a pencil, lightly draw a circle for the outline of the head and a vertical and a horizontal line dividing it into four equal quadrants. Position the facial features on the horizontal and vertical lines, giving your doggy a content facial expression.

2. Draw the floppy ears off the upper quadrants.

3. Draw the top of the head, following the top curve of the circle.

4. Draw the sides of the head with fur detail.

5. Complete the head with a curved line that follows the bottom of the circle.

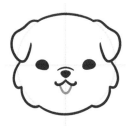

6. Finish by giving your doggy a playful tongue. Erase your guidelines.

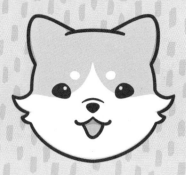

1. With a pencil, lightly draw a circle for the outline of the head with a vertical and a horizontal line dividing it into four equal quadrants. Position the facial features on the horizontal and vertical lines, giving your doggy a content facial expression.

2. Draw the pointy ears angled off the upper quadrants.

3. Draw the slightly curved line of the top of the head inside the circle.

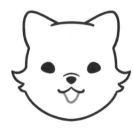

4. Draw the sides of the head with fur detail.

5. Complete the head with a curved line that follows the bottom of the circle.

6. Finish by giving your doggy a playful tongue. Erase your guidelines.

PUG

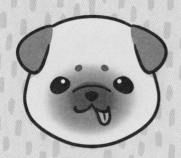

1. With a pencil, lightly draw a circle for the outline of the head and a vertical and a horizontal line dividing it into four equal quadrants. Position the facial features on the horizontal and vertical lines, giving your doggy a content facial expression.

2. Draw the droopy ears off the upper quadrants.

3. Draw the top of the head, following the top curve of the circle.

4. Complete the head with a wide U shape that follows closely to the sides and bottom of the circle.

5. Finish by giving your doggy a playful tongue. Erase your guidelines.

CAVALIER KING CHARLES SPANIEL

1. With a pencil, lightly draw a circle for the outline of the head and a vertical and a horizontal line dividing it into four equal quadrants. Position the facial features on the horizontal and vertical lines, giving your doggy a content facial expression.

2. Draw the outsides of the floppy ears off the upper quadrants.

3. Complete the ears by drawing the bottoms and insides.

4. Draw the top of the head, following the top curve of the circle.

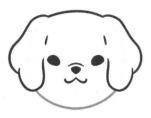

5. Complete the head with a curved line that follows the bottom of the circle. Erase your guidelines.

SAMOYED BORDER COLLIE MIX

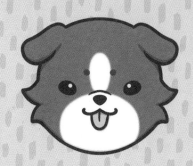

1. With a pencil, lightly draw a circle for the outline of the head and a vertical and a horizontal line dividing it into four equal quadrants. Position the facial features on the horizontal and vertical lines, giving your doggy a content facial expression.

2. Draw the floppy ears off the upper quadrants.

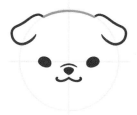

3. Draw the top of the head, following the top curve of the circle.

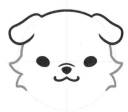

4. Draw the sides of the head with spiky fur detail.

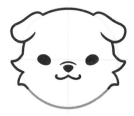

5. Complete the head with a curved line that follows the bottom of the circle.

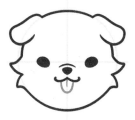

6. Finish by giving your doggy a playful tongue. Erase your guidelines.

1. With a pencil, lightly draw a circle for the outline of the head and a vertical and a horizontal line dividing it into four equal quadrants. Position the facial features on the horizontal and vertical lines, giving your doggy a content facial expression.

2. Draw the pointy ears angled off the upper quadrants.

3. Draw the top of the head, following the top curve of the circle.

4. Draw both sides of the head with fur detail.

5. Complete the head with a curved line that follows the bottom of the circle. Erase your guidelines.

DALMATIAN

1. With a pencil, lightly draw a circle for the outline of the head and a vertical and a horizontal line dividing it into four equal quadrants. Position the facial features on the horizontal and vertical lines, giving your doggy a content facial expression.

2. Draw the floppy ears off the upper quadrants.

3. Draw the top of the head, following the top curve of the circle.

4. Complete the head with a wide U shape that follows closely to the sides and bottom of the circle. Erase your guidelines.

1. With a pencil, lightly draw a circle for the outline of the head and a vertical and a horizontal line dividing it into four equal quadrants. Position the facial features on the horizontal and vertical lines, giving your doggy a content facial expression.

2. Draw the floppy ears off the upper quadrants.

3. Draw the slightly curved line of the top of the head inside the circle.

4. Draw short lines below the ears for the start of the sides of the head.

5. Complete the head with a wide U shape to emphasize the jowls. Erase your guidelines.

FRENCH BULLDOG

1. With a pencil, lightly draw a circle for the outline of the head and a vertical and a horizontal line dividing it into four equal quadrants. Position the facial features on the horizontal and vertical lines, giving your doggy a content facial expression.

2. Draw the pointy ears angled off the upper quadrants.

3. Draw the top of the head, following the top curve of the circle.

4. Draw short lines below the ears for the start of the sides of the head.

5. Complete the head with a wide U shape to emphasize the jowls. Erase your guidelines.

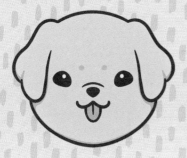

GOLDEN RETRIEVER

1. With a pencil, lightly draw a circle for the outline of the head and a vertical and a horizontal line dividing it into four equal quadrants. Position the facial features on the horizontal and vertical lines, giving your doggy a content facial expression.

2. Draw the top of the head, following the top curve of the circle.

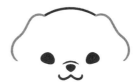

3. Draw the outsides of the floppy ears off the upper quadrants.

4. Complete the ears by drawing the bottoms and insides.

5. Complete the head with a curved line that follows the bottom of the circle.

6. Finish by giving your doggy a playful tongue. Erase your guidelines.

DOGGY COLORING PAGES

Wait, there's more! Have fun coloring, adding markings, decorating, or even accessorizing the doggies on these pages. You can follow the color palette and marking inspiration on page 14 or be original. It's up to you!

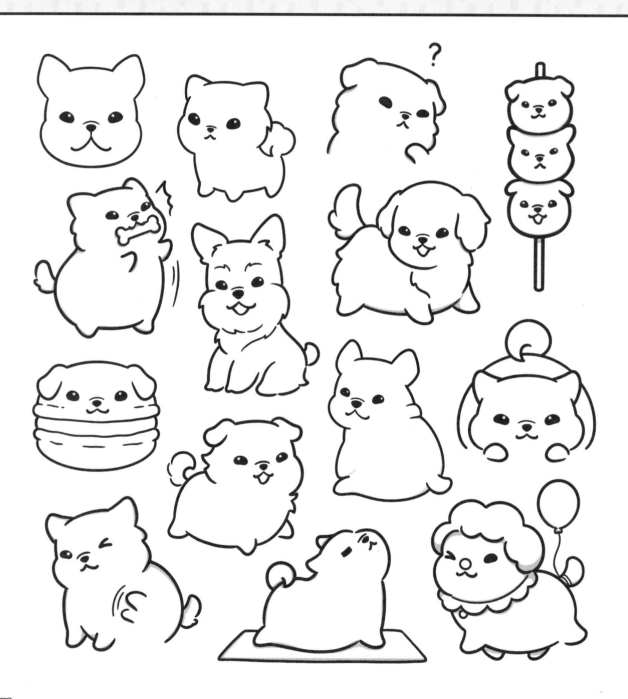

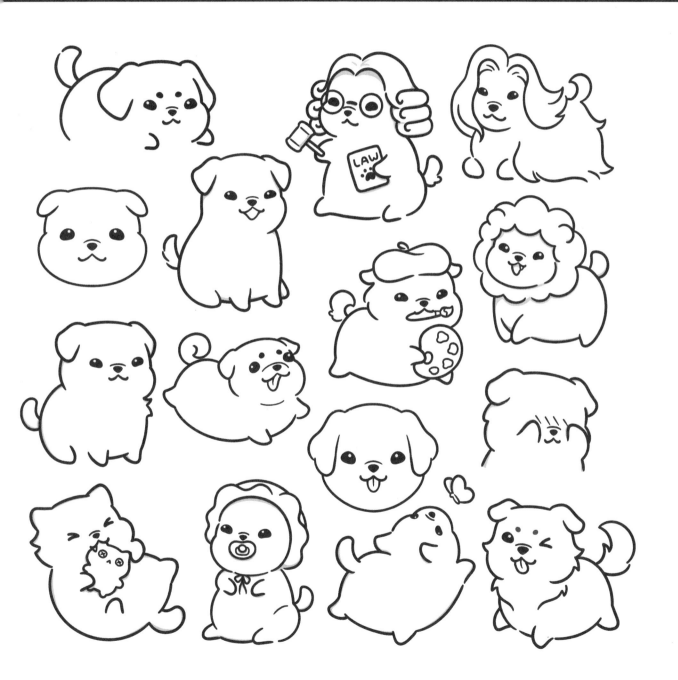

DOG BREED DIRECTORY

Here's a handy directory to find your favorite dog breed(s) in the book. It is organized by the seven groups featured at dog shows, along with a mixed breed category. (NOTE: Though we feature dog breeds in the book, we encourage you to adopt and love all the mutts out there in the world and have included illustrations of them throughout the book.)

Toy Group

Maltese 20, 61

Pug 28, 65, 132

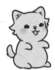
Chihuahua 49

Poodle 50

Cavalier King Charles Spaniel 32, 133

Papillon 41, 62

Yorkshire Terrier 53

Pomeranian 45

Hound Group

Dachshund 19

Afghan Hound 35

Beagle 37, 57

Herding Group

German Shepherd 42, 135

Australian Shepherd 47, 130

Terrier Group

Bull Terrier 23

Jack Russell Terrier 25

Miniature Schnauzer 36, 58

American Staffordshire Terrier 46, 137

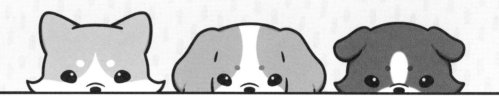

Working Group

Boxer 24

Great Dane 26

Siberian Husky 27, 60

Bernese Mountain Dog 30

Saint Bernard 43, 65

Rottweiler 52

Corgi 40, 131

Sporting Group

Golden Retriever 18, 139

Labrador Retriever 21, 63

Non-Sporting Group

Chow Chow 22

French Bulldog 29, 56, 138

Dalmatian 33, 136

Boston Terrier 34

Shiba Inu 38, 59

Bichon Frise 44

Mixed Breed

Maltipoo 31

Samoyed Border Collie Mix 39, 134

English Bulldog 48

IF YOU ENJOYED KAWAII DOGGIES, CHECK OUT THESE OTHER LEARN-TO-DRAW BOOKS!

Kawaii Kitties
Learn How to Draw 75 Cats in All Their Glory
ISBN: 978-1-63106-739-6

Cute Chibi Mythical Beasts & Magical Monsters
Learn How to Draw Over 60 Enchanting Creatures
ISBN: 978-1-63106-872-0

Cute Chibi Animals
Learn How to Draw 75 Cuddly Creatures
ISBN: 978-1-63106-729-7

Kawaii Doodle World
Sketching Super-Cute Doodle Scenes with Cuddly Characters, Fun Decorations, Whimsical Patterns, and More
ISBN: 978-1-63106-697-9

Chibi Art Class
A Complete Course in Drawing Chibi Cuties and Beasties
ISBN: 978-1-63106-583-5

Anime Art Class
A Complete Course in Drawing Manga Cuties
ISBN: 978-1-63106-764-8